HALLOWEEN CURSES

The Scary Swears

13 Gruesome Frights to Color In

M. Ernstsen

Presented By

Odins Valkyrie

The Horrors You Will Encounter Here

Beware of Shit Filled Twinkies
Clean the Cobwebs From Your Twat
Cum Sucking Cock Monster
Damn You to Hell!
Dirty Rotton Drippy Pussy Eater
Disguise Your Diseased Dick
Douche Your Cunt Face
Dumb Fucking Bleach Blonde Skank
Fuck Off and Die!
Get the Bats Out of Your Ass
Haggard Heathen Whore
Hop on Your Broom You Baggy Vag Hag
Shit Faced Clit Licker

I've also included a special treat for you at the end of the book so no trying to trick me!!

Enter If You Dare!!

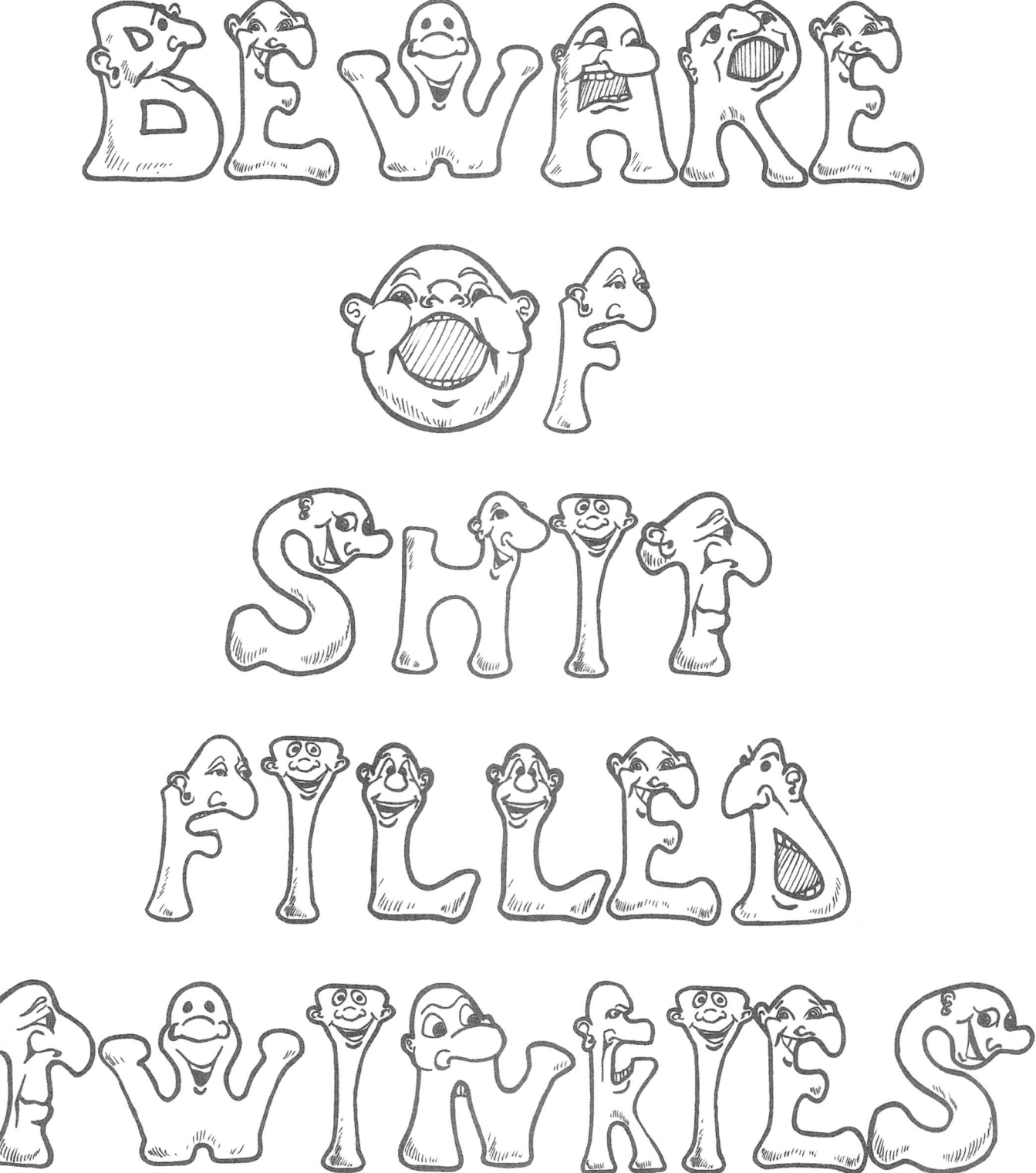

Clean The Cobwebs From Your Twat

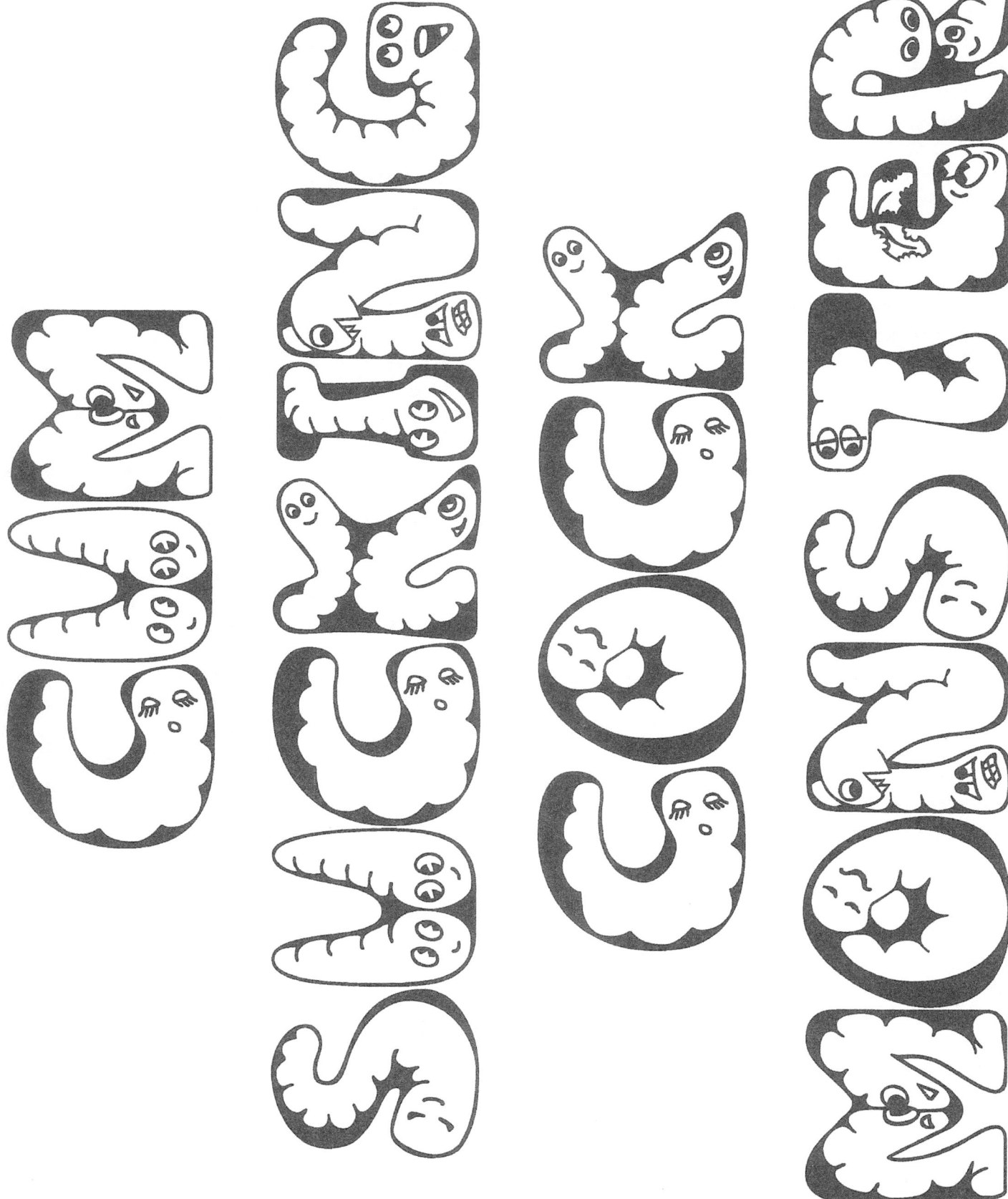

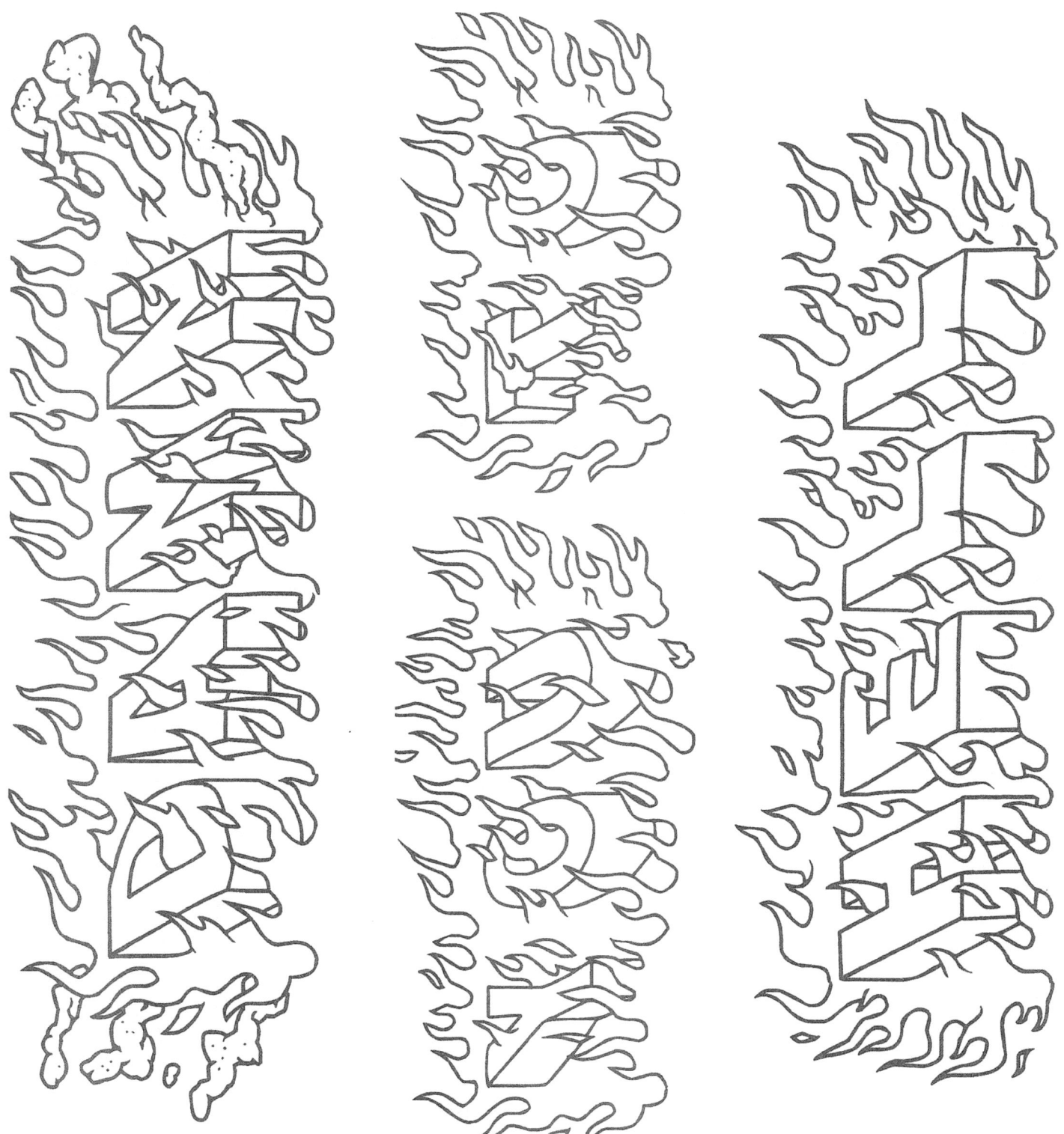

DIRTY ROTTEN DRIPPY PUSSY EATER

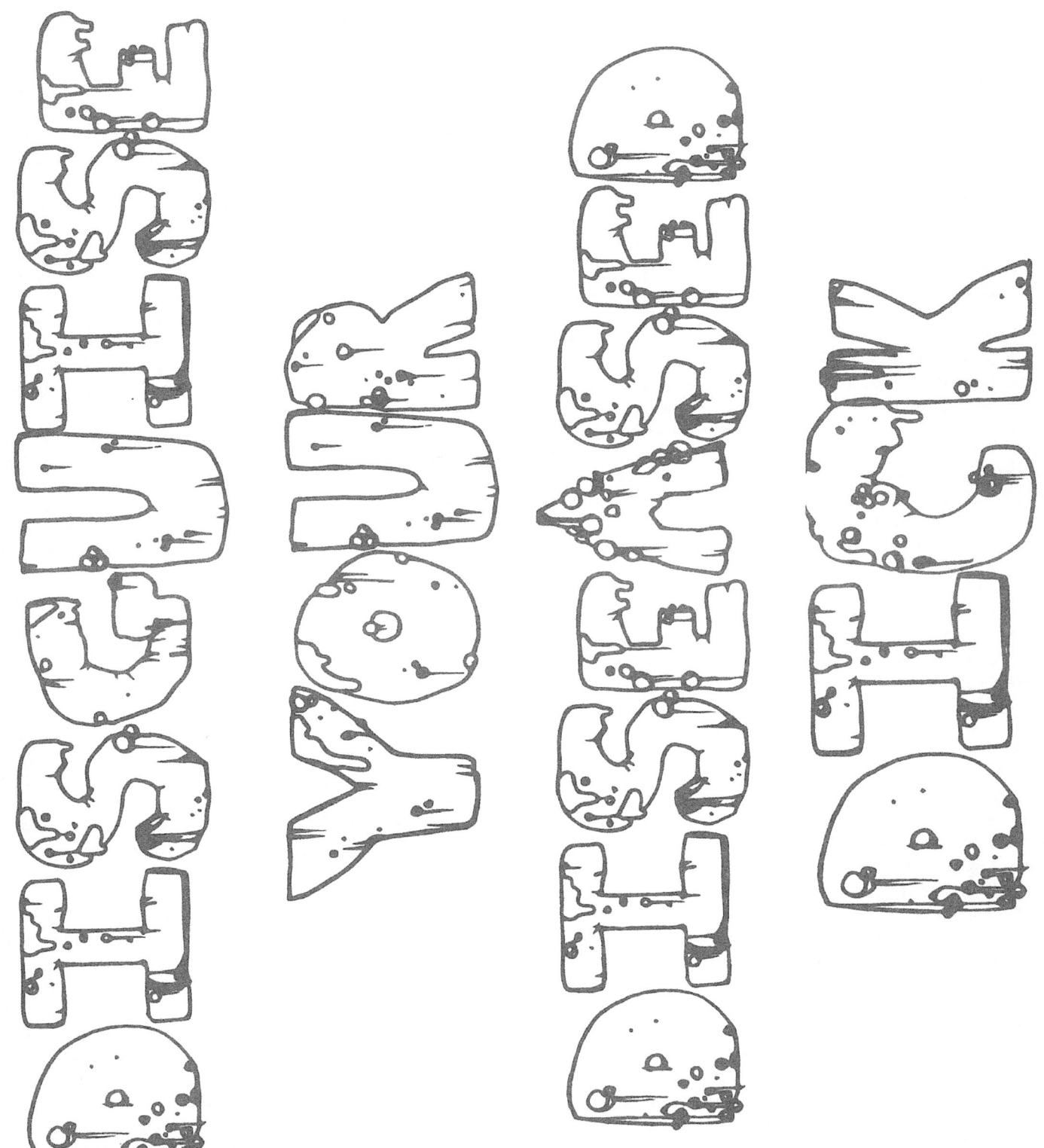

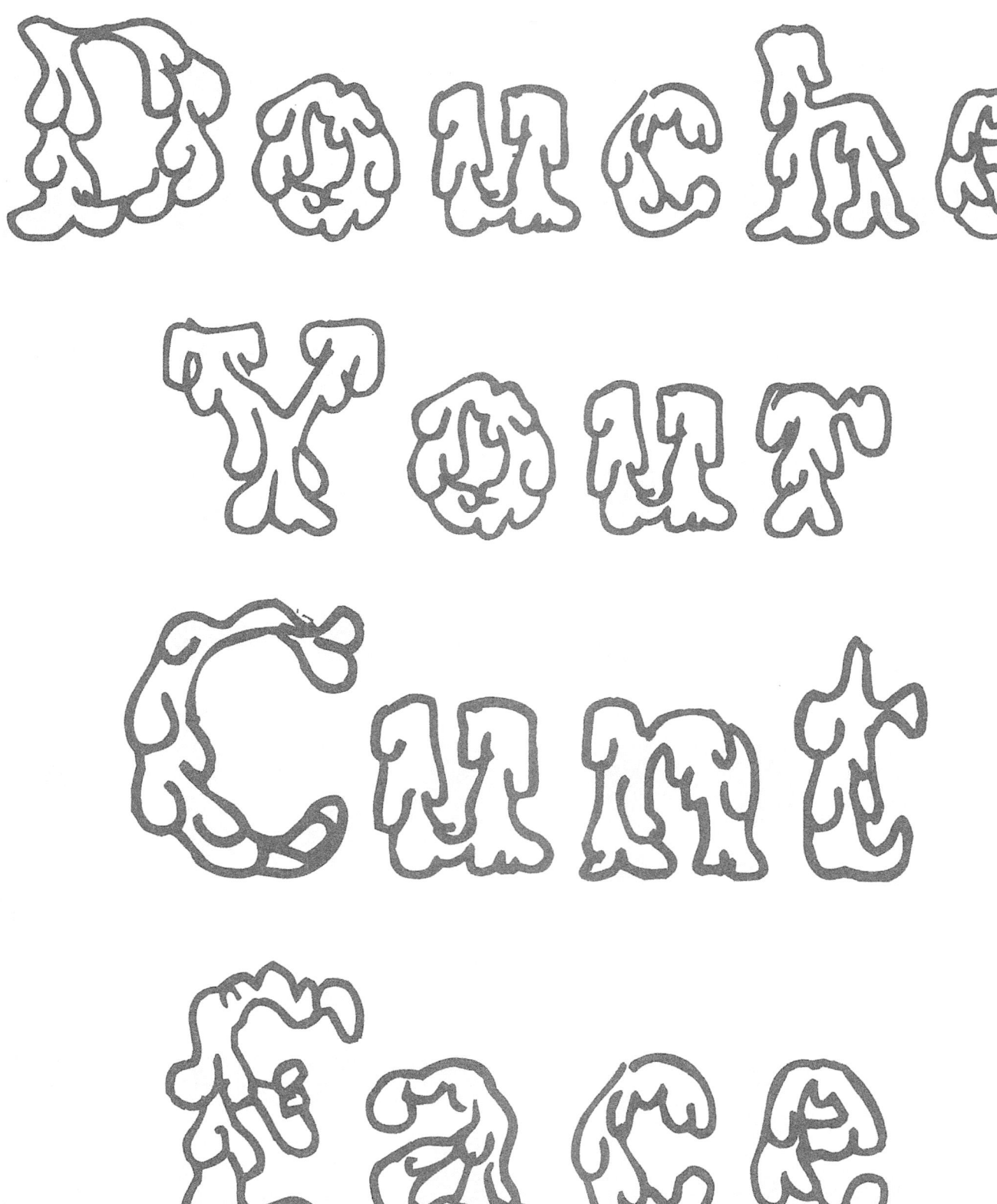

Dumb
Fucking
Bleach
Blonde
Skank

Fuck off and Die!

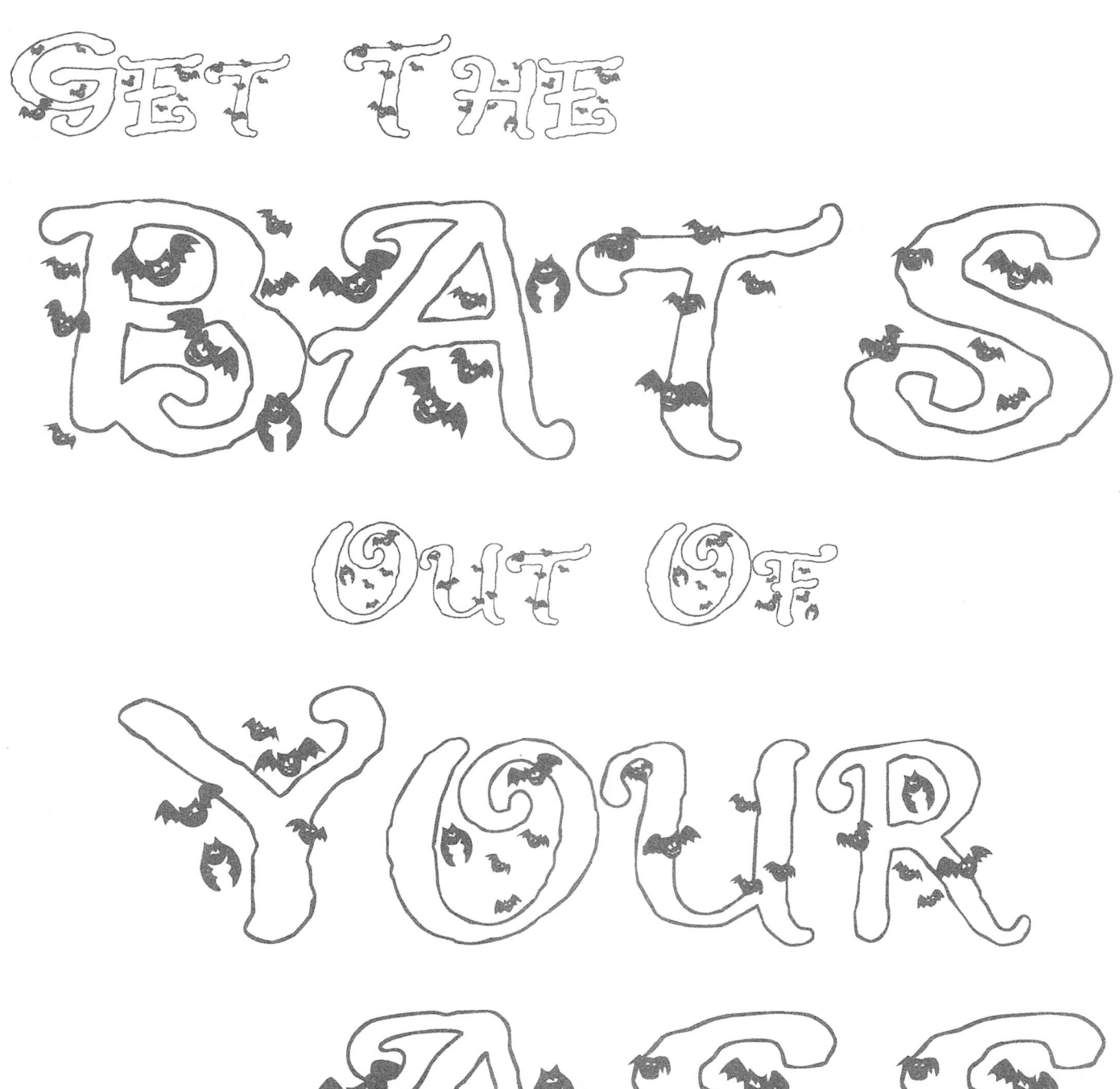

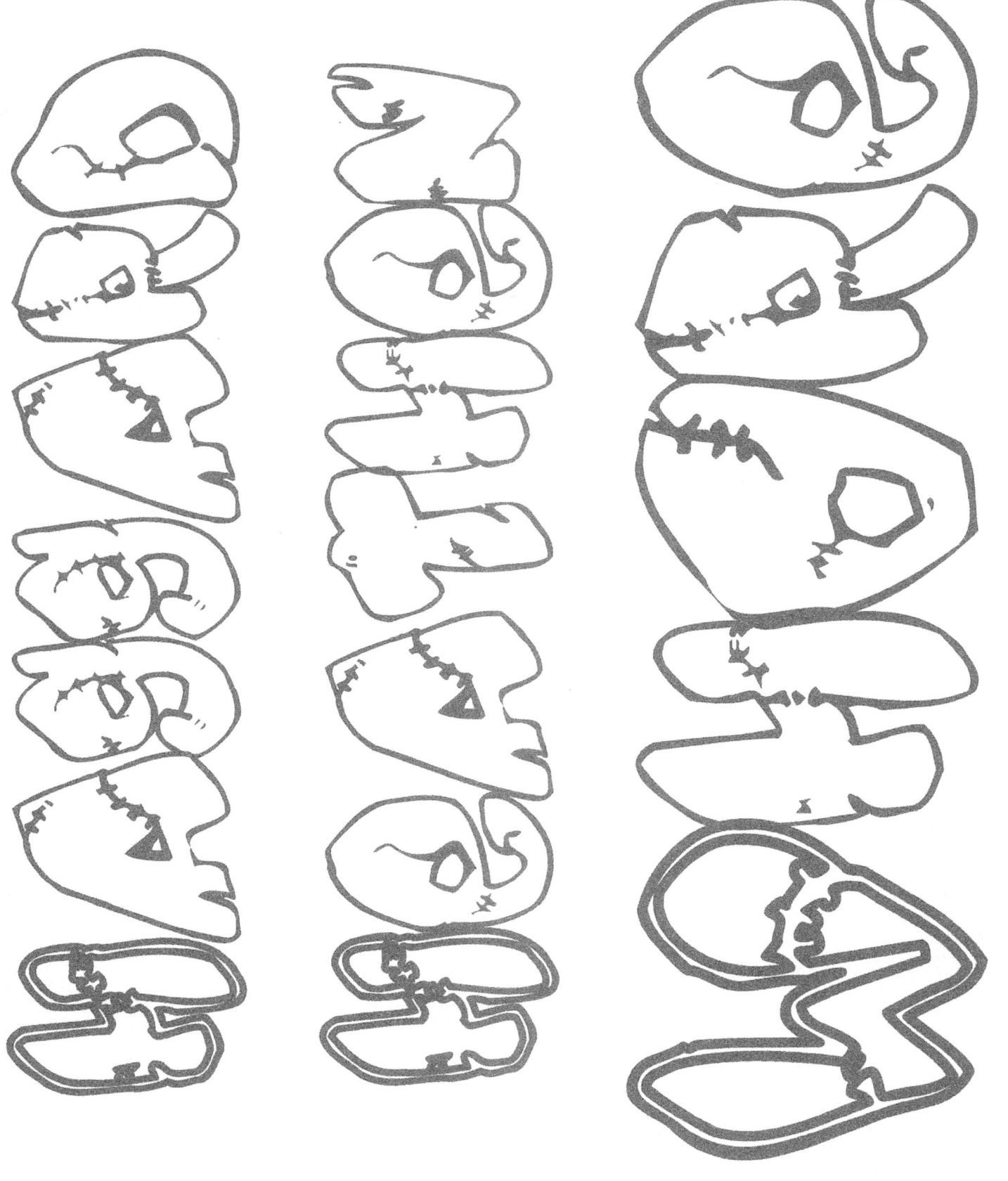

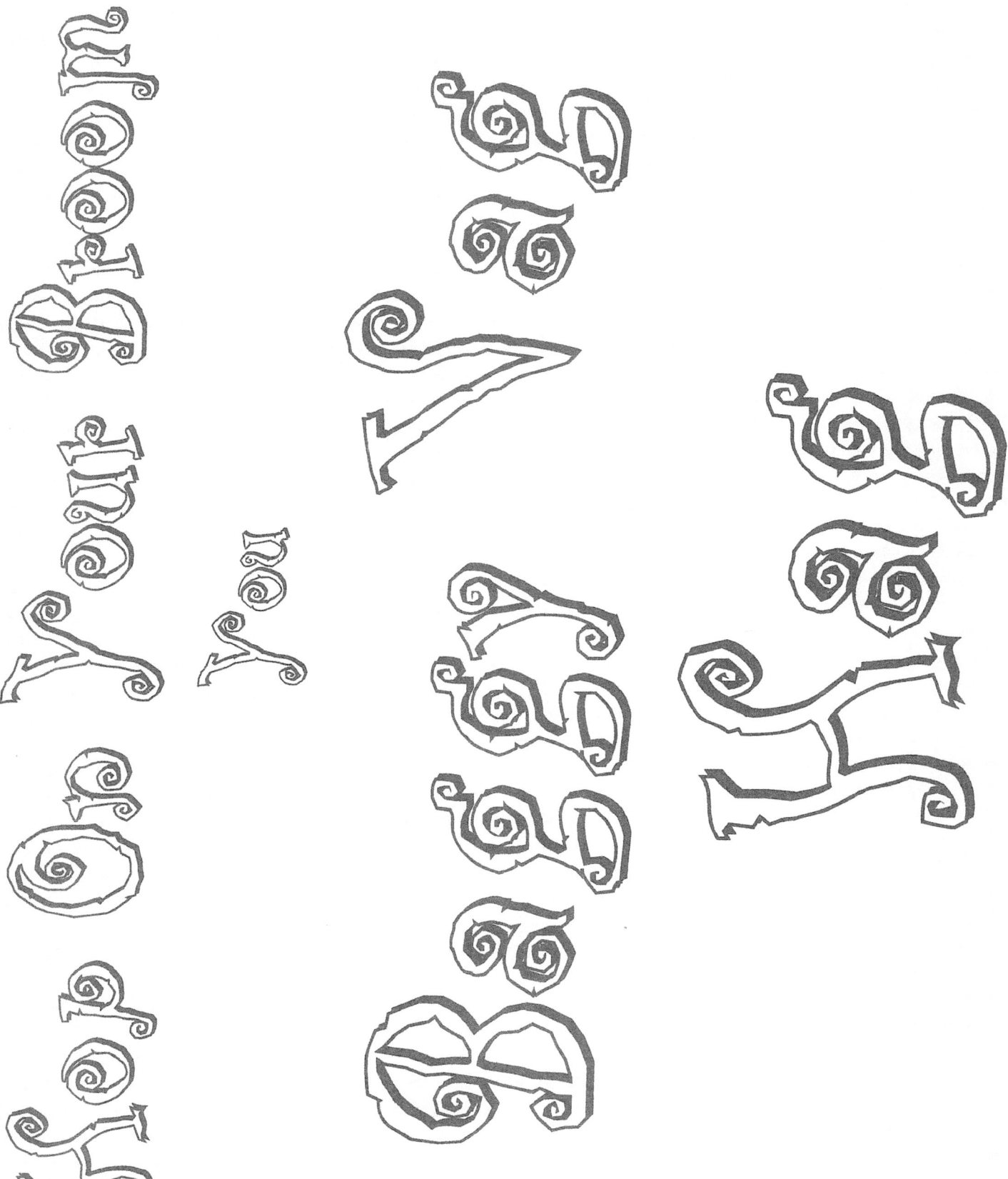

Shit Faced Clit Licker

I promised you a Treat at the end of the Curses!!

The next 8 pages contain 117 images:

Gargoyles, Monsters, Skulls, Ghosts, Witches, Sugar Skulls and many more scary images

Print any (or all!!) of the pages

Customize your Curses!!

Use the images to trace or copy onto your completed "Halloween Curses" ~ Make them your own unique Curses

PLUS: Pages for you to color!!

2 pages with 4 "Happy Halloween" images

and 1 full page surprise at the very end ~

If you make it that far!!

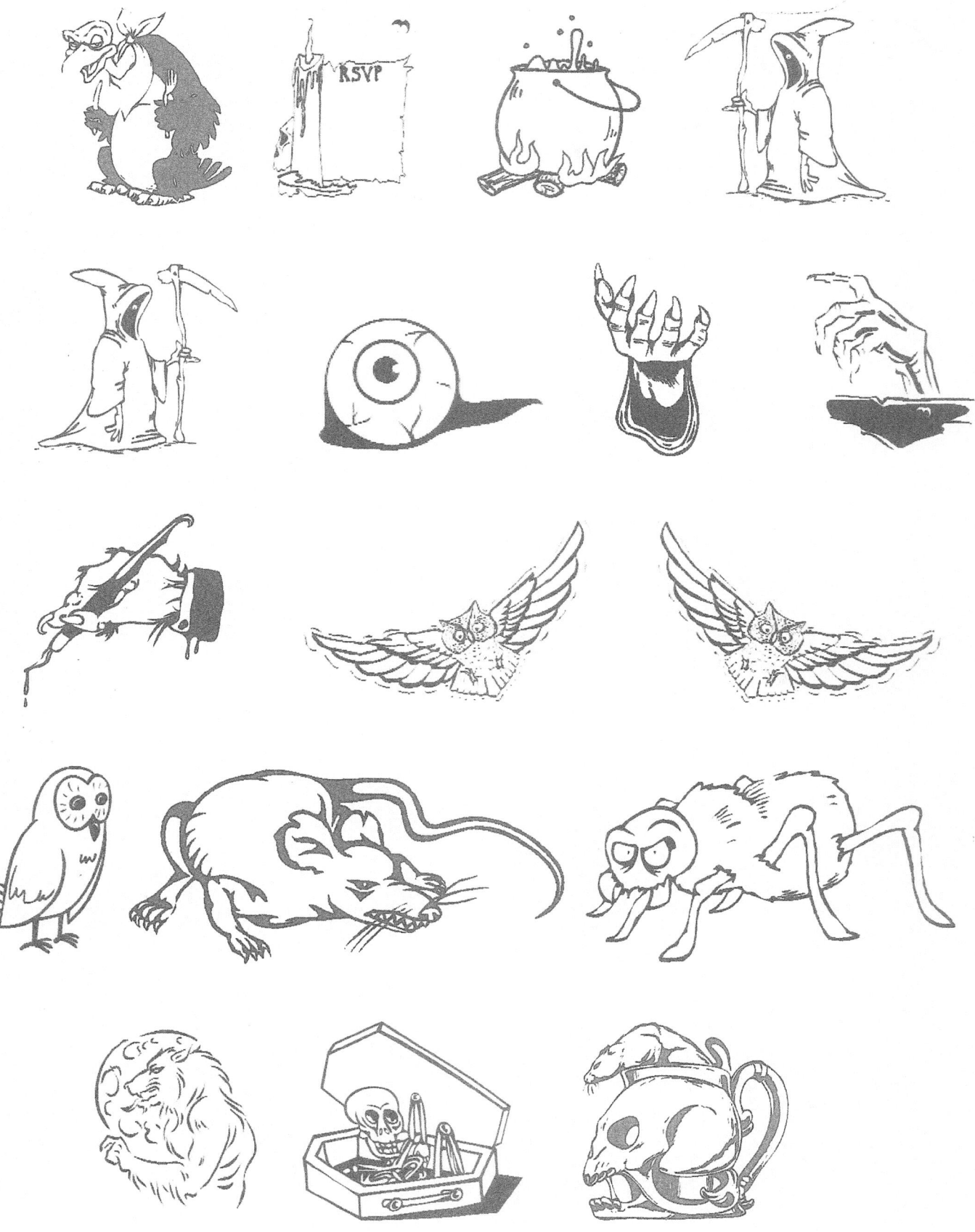

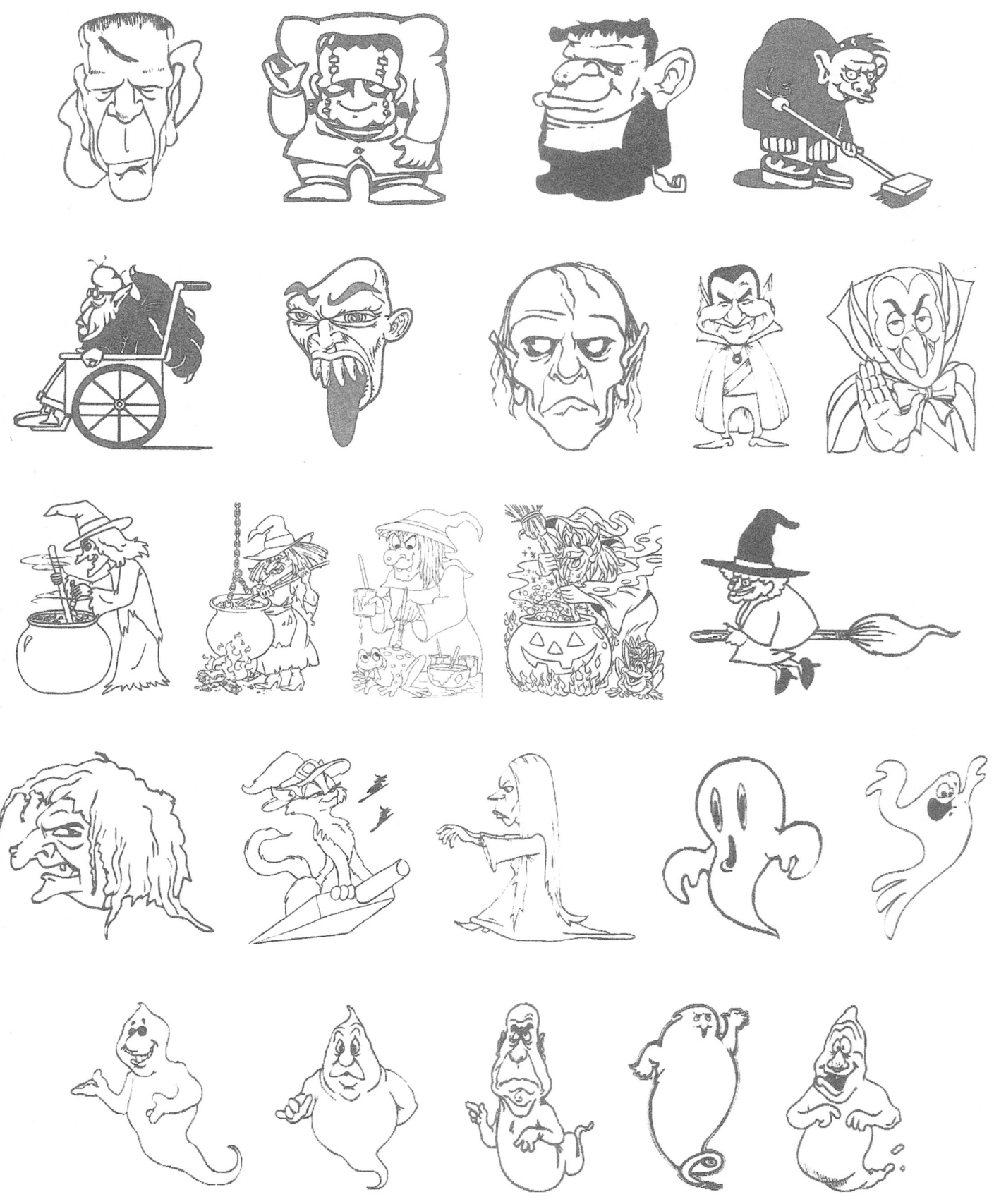

 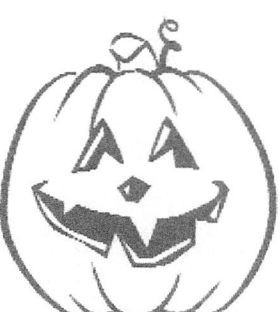

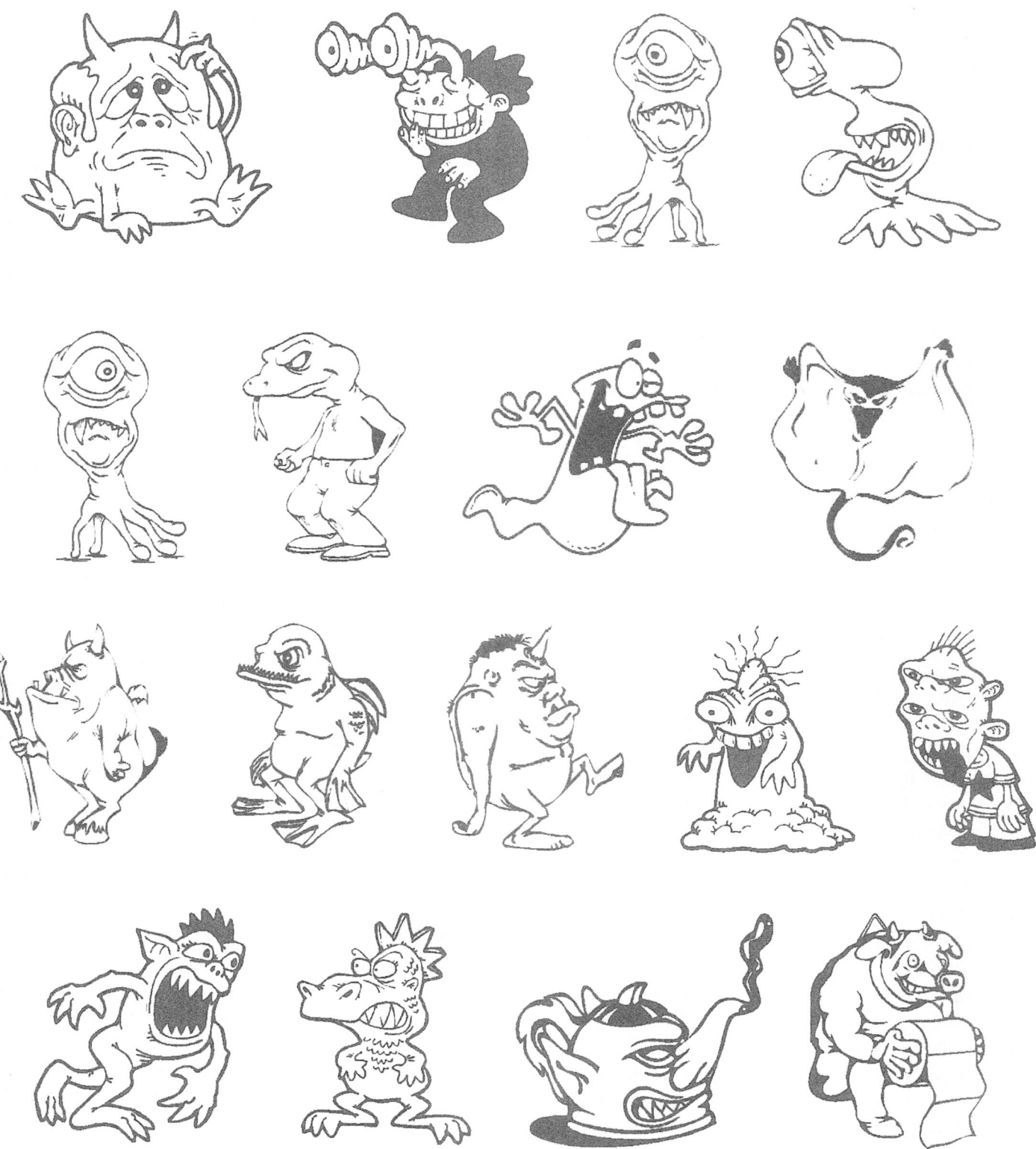

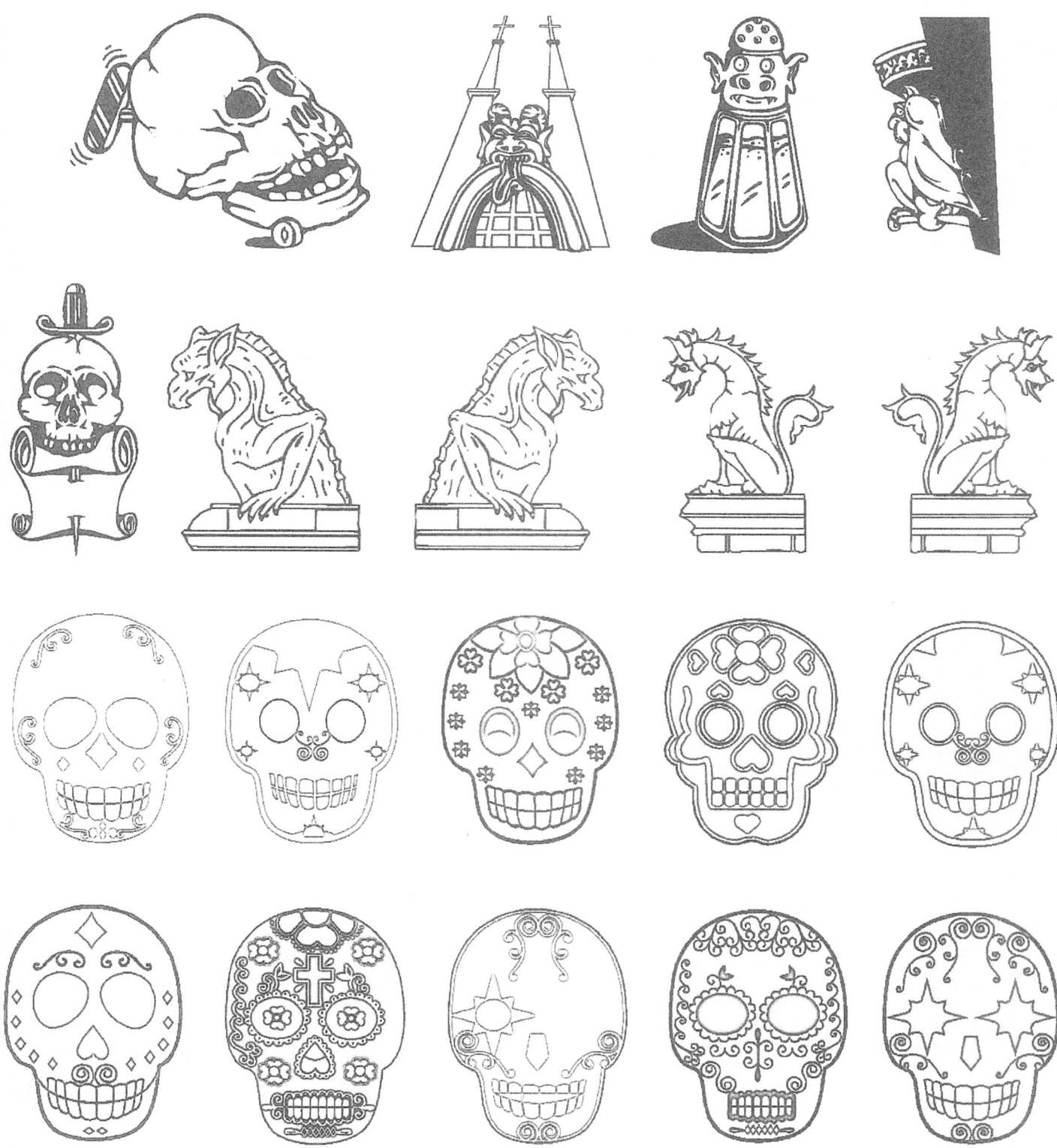

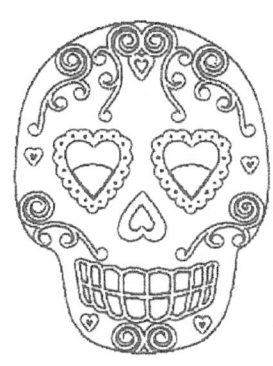

Happy Halloween

Halloween Treats

HALLOWEEN

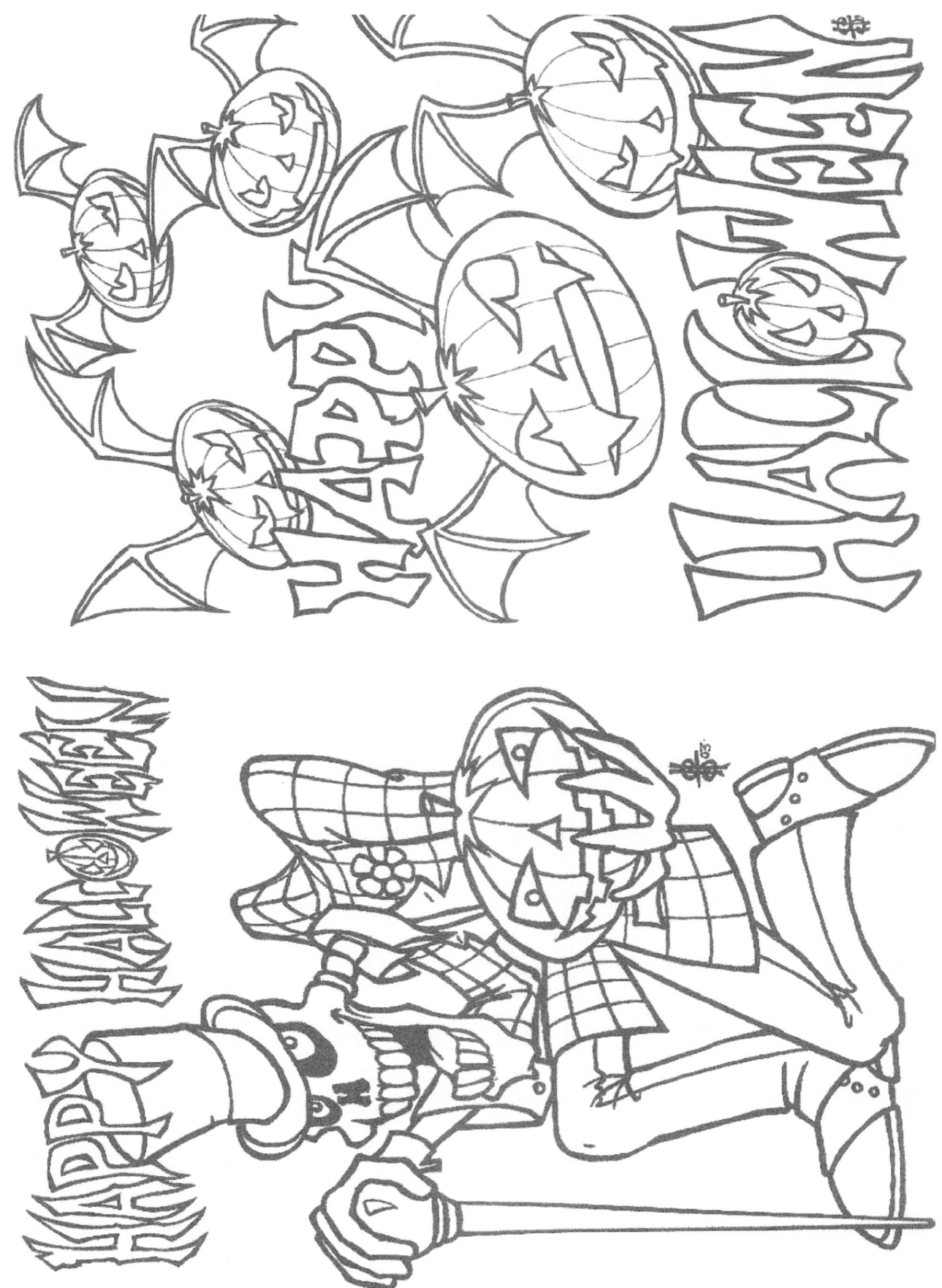

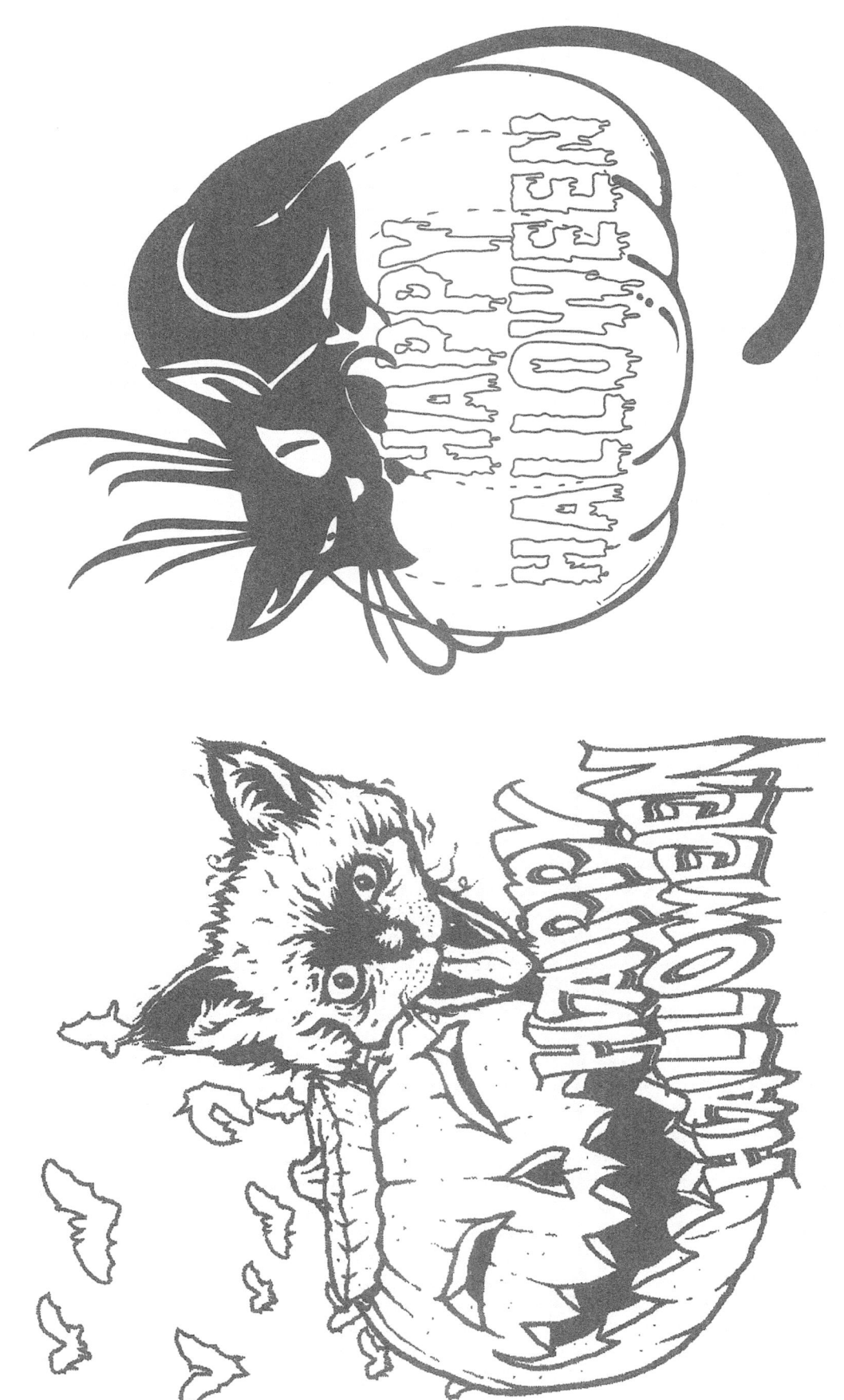

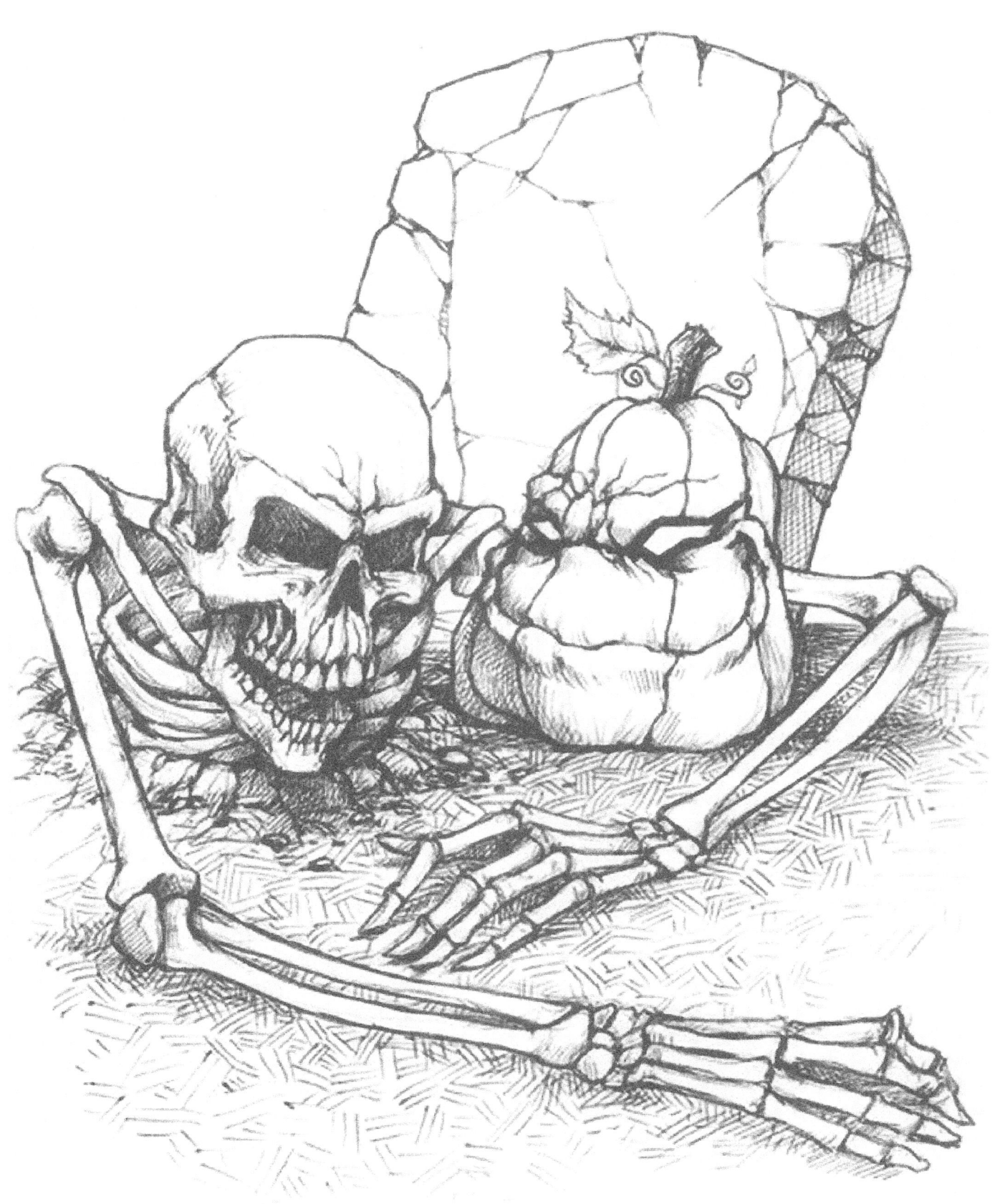

Download your PDF file at:

https://1drv.ms/b/s!Aslz6SCeSCMObPahdcmpv_I1qow

If you encounter any problems email me at:

OdinsValkyrie@comcast.net

Email me your completed pics – I am working to get a Facebook page to show off your beautiful art

Email me any comments you may have too!!

Coming next: Kids ABC – Scary Monsters

Coming soon: Kids ABC (Series)
– I have several in the works

Dominatrix Says (Series)
- Holiday Commands
- Christmas Commands
- Under the Tree

Hope to hear from you!!